Imagined Lives

Portraits of unknown people

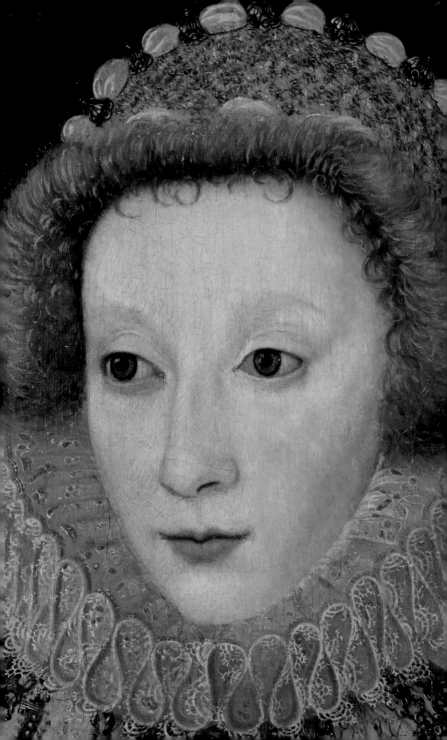

Imagined Lives

Portraits of unknown people

FICTIONAL CHARACTER SKETCHES BY

John Banville

Tracy Chevalier

Julian Fellowes

Alexander McCall Smith

Terry Pratchett

Sarah Singleton

Joanna Trollope

Minette Walters

National Portrait Gallery, London

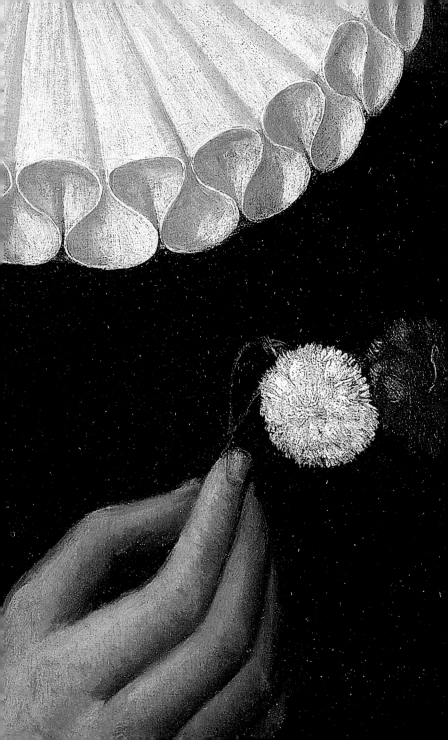

CONTENTS

Introduction

The portraits in this book are mysterious. They were acquired by the National Portrait Gallery between 1858 and 1971 when they were identified as depicting known sitters such as the hapless Scottish queen, Mary Stuart, the traitor Thomas Howard (Duke of Norfolk) and the poet William Drummond. Since this time their identities have been disproved or disputed and the portraits were removed from display or lent to other collections. And yet, each of the faces that looks out from the pages of this book depicts a person once alive, but now lost to us. This book and the accompanying display have provided an opportunity to investigate and rediscover these little-known sixteenth- and seventeenth-century paintings both as telling works of art and as objects of curiosity and wonder.

The portraits have inspired eight internationally renowned writers to craft fictional biographies and imaginary character sketches about each sitter. The results provide an intriguing, touching and sometimes amusing way to look at portraits from the past. Their short fictional narratives respond to what can be seen in each painting, picking up on details in the costumes and poses in ways that provoke our curiosity about the sitter. For example, the writer Alexander McCall Smith has imagined an alternative life – as a body double for Mary, Queen of Scots – for a beautiful young woman depicted in a portrait once identified as the Scottish queen. In a piece entitled 'Rosy', historical novelist Tracy Chevalier has written about a handsome young man with a flushed complexion as the object of homosexual desire. The crime writer Minette Walters has written a poignant letter from the perspective of a woman who brims with despair at her husband's extravagance in commissioning his portrait. The author and scriptwriter Julian Fellowes has created a subtle biography (written in the style of a traditional biographical entry in an encyclopedia) about a resourceful woman whose husband was executed in the reign of Henry VIII. Sarah Singleton, a journalist and writer of fiction for young adults, has written about the adventures of a

spice merchant and amateur musician struggling to make his way in the world despite his illegitimate status. A tale about a marriage proposal written in the form of a letter from the sitter's intended young bride is one of the subjects of the novelist Joanna Trollope's moving tale. In a complete change of tone, the fantasy writer Terry Pratchett has written a witty story about an explorer who presented Queen Elizabeth I with a skunk. Finally, novelist John Banville has seen in the features of a man lying upon his death bed the face of a brave officer serving with Cromwell's New Model Army. All these writers have looked at these faces from the past and created imagined narratives, breathing new life into the labels 'unknown man' and 'unknown woman'.

Recent conservation work and new research has meant that some of the portraits can now be linked with possible identities. We hope that the publication of these portraits may encourage further research. However, it is likely that most of the portraits will remain unidentified. The final section of the book asks why portraits might lose their identities, what this tells us about immortality, how the identity of sitters might be rediscovered and it explores the little we know about the artistic and cultural contexts of these intriguing portraits.

We are grateful to the authors for sharing these remarkable stories with us, and for their creative and playful response to the challenge of re-imagining the lives of these unidentified sitters.

TARNYA COOPER

False Mary Alexander McCall Smith

'It is a great thing that I, a merchant's daughter, should spend many hours pretending to be the Queen herself.'

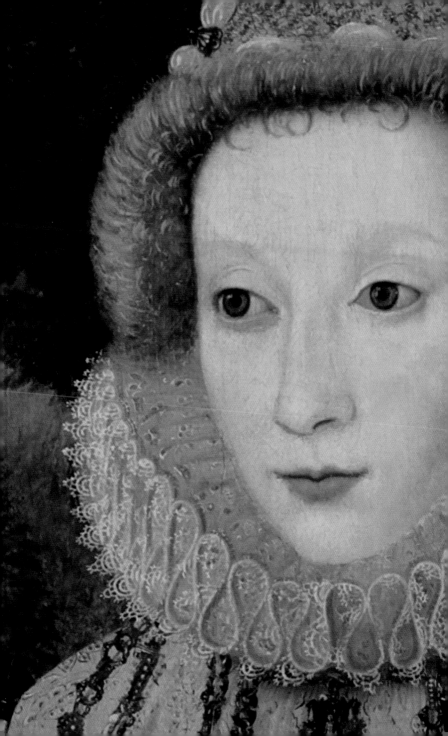

False Mary

Mary Peebles, or 'False Mary' as she came to be known, is one of the most unusual figures of Scottish sixteenth-century history. She was the daughter of an Edinburgh merchant, a man who had prospered sufficiently to be noticed on the fringes of the Holyrood court of Mary Stuart, Queen of Scots. This court, of course, was a hotbed of intrigue, a dangerous place for anybody, including a young queen, to be. The Scottish nobles, a bickering and ruthless group, thought nothing of murder as a means of securing their goals, and were not above bringing their murderous schemes into the heart of the Queen's household.

After the slaughter of her Italian secretary, David Rizzio, Mary Stuart realised that she could trust virtually nobody, including her husband, the vain and scheming Henry Darnley. It is not known how she came to the decision, but shortly after this murder she formed the view that she needed to employ a body double. This device was later to be used by a variety of shady twentieth-century dictators, but it was not unknown to prominent figures in the past. The body double could serve more than one purpose: he or she would enable the real person to be in more places more frequently, to obvious political advantage. The double could also draw the fire of those plotting to kill the real king or queen – an occupational hazard for doubles, of course, but grounds for great reward, even if posthumously enjoyed.

Mary Peebles did not resemble Mary Stuart in her colouring or even in her facial appearance, but, very importantly, she was exactly the same height as the Queen, and had a very similar gait and bearing. These factors were enough to make her an obvious choice, and she, naturally enough, accepted the role. It did not at first occur to her that she would be a target for assassins; for her, it was a great

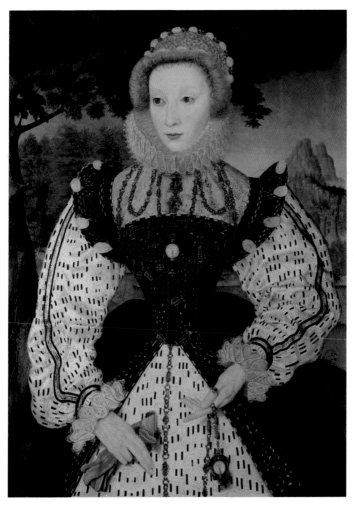

Unknown woman, formerly known as
Mary, Queen of Scots (1542–87), c.1570

Overleaf
Detail of the timepiece worn
around the woman's neck.

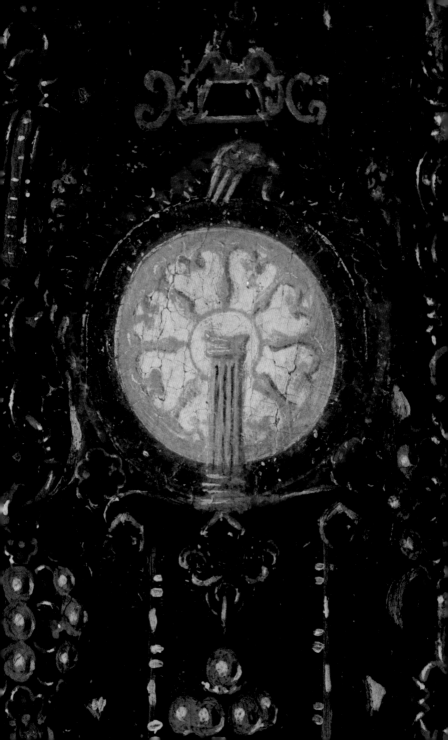

adventure, enabling her to inhabit regal quarters and enjoy the French style that Mary brought to the dismal Scottish court.

The Queen liked her and taught her French and deportment. She encouraged her to sit for the numerous Italian portrait painters who attended her court; Mary Stuart herself did not enjoy sitting for portraits, as she found the formal clothing stifling and could not endure hours of immobility in it. In particular, she did not like the constraint to which her waist was subjected. Mary Peebles, by contrast, did not mind this, as she was naturally slim-waisted. 'Corsets hold no terrors for me,' she said. 'Nor does the weight of jewels burden me unduly. I am content in this employment that the Queen has so graciously given me. It is a great thing that I, a merchant's daughter, should spend many hours pretending to be the Queen herself, waving from my horse to the small children of the town, dispensing alms as if they were from my own purse, occasionally even doing justice in confining some rogue or vagabond to his just punishment. And the Queen is most kind to me, and gives me the delicate jams that she has sent to her from France. I dine well most nights.'

She soon came to understand, though, the essentially temporary nature of a body double's work. She now realised that it was only a matter of time before she encountered an assassin's knife, and so she took to sitting for portraits bearing an iconographical timepiece, occasionally even two, lest the point be missed. She also detested Darnley, who on several occasions forced his attentions on her and then claimed that he had thought she was his wife. She hated him, and when he was blown up at Kirk o'Field, she devised a courtly dance, performed to the words: *Darnley is gone skywards, sing hurrah.* The words reveal the depth of her feeling, so much so that some suspected that she was involved in the plot against him, or even instigated it.

Nobody knows what happened to her.

ALEXANDER McCALL SMITH

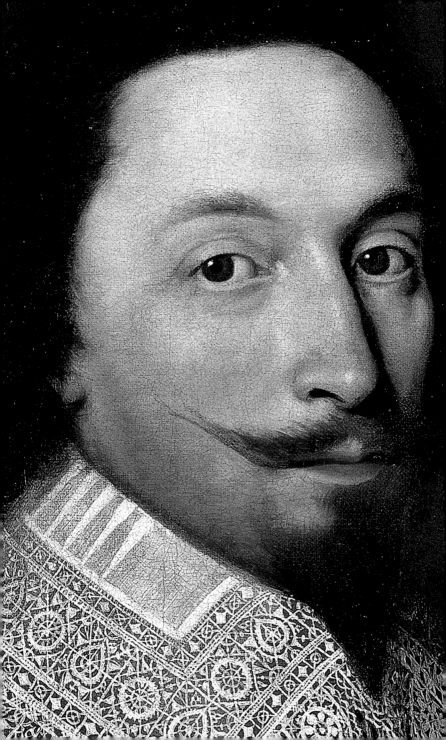

Mathilda's Letter Minette Walters

'You are married to a libertine and I to a fortune-hunter.'

Mathilda's Letter

Amsterdam, Holland

My dear Sister,

Certainly my husband looks handsome in his portrait, and indeed he should. We are beggared by the payment for it. Monsieur Cornelius de Neve describes himself as 'an artist without equal' and commands absurd sums to paint his subjects in the style of the King or the Duke of Buckingham.

Jan's admiration for it, too, is without equal, since he appears quite unable to see that it bears no likeness to him whatsoever. He stands before it, admiring himself prodigiously, and waves aside my concerns that Jan de Groot in person may prove a disappointment to a future patron who has seen only the painting. He utters phrases such as 'a man who presents himself well will sell himself well', or 'a soldier of fortune must risk all to gain all'.

My heart sinks every time I think of the money he has spent. The rental of the armour and the lace collar cost more than it takes to feed the household for a quarter year, and I dare not relate how much it took to manufacture a crimson sash, embroidered in silver and gold, that bears resemblance to those worn by officers in the Dutch Army. I am deeply afraid that it may be treasonable to pretend membership of the officer class, but Jan dismisses my fears as womanly weakness.

You say I have no sympathy for your plight, but I do. Father made bad matches for both of us and I go to sleep at night wishing him in purgatory. You are married to a libertine and I to a fortune-hunter who has squandered my marriage settlement on cards and dice. Though Jan be only thirty-five, his cheeks and nose are threaded with the signs of dissolution from nights spent

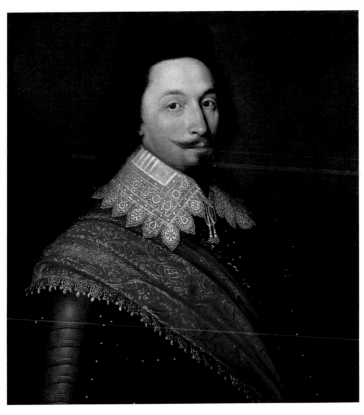

Unknown man, formerly
known as George Villiers,
1st Duke of Buckingham
(1592–1628), 1627

at the Burgerdijk, but no one would believe that from Monsieur de Neve's flattering depiction.

My husband is as deluded as he is profligate. I was obliged to break off from penning this letter to you because he entered my little room and stamped around me, shaking his fist in the air. And for what reason? He received information this morning that King Charles, under the influence of his Catholic Queen, rejects Calvinism as practised by the Dutch and plans to take England back to the tradition and sacrament of the old religion.

It seems we must pay Monsieur de Neve again for the purpose of over-painting the Dutch officer's sash. To this end, Jan has set off in search of him and has instructed me to make enquiries on the hire of Catholic regalia. I must therefore end this missive to you, dear Sister, though I expect to write again before too long.

I have told you before of the wondrous marvel of the waterways that run through Amsterdam. Jan warns me daily to be careful around them for it is said that a person, even one able to swim, will be swept towards the sea in less than two hours, and his body lost for ever. If I speed, I may be able to catch up with him before he reaches Monsieur de Neve. It is a pity, perhaps, that among his other failings, my worthless husband has never mastered the art of staying afloat.

Your ever-loving Sister
Mathilda

MINETTE WALTERS

Opposite
Detail of the sash, embroidered
with silver and gold thread.

I Am Mary Douglas Minette Walters

'A man who picks a wife from a parade of canvases will care nothing for her feelings.'

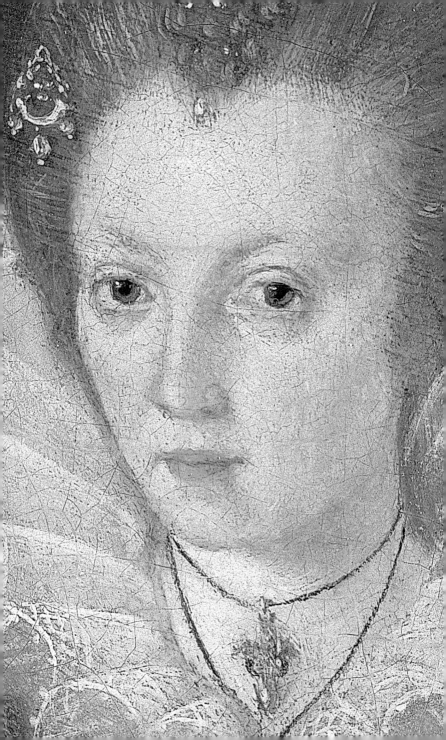

I Am Mary Douglas

I am Mary Douglas, daughter of Matthew and Jane Douglas, granddaughter of David Douglas and great-granddaughter of Archibald Douglas, 6th Earl of Angus. Through the Earl's marriage to Margaret Tudor, I am distantly related to Elizabeth of England and James VI of Scotland, and for this reason I must marry appropriately.

How heavily that injunction weighs on my heart. My cousin, Lady Arabella Stuart, who some believe will one day inherit the throne, remains unwed at twenty-four because the intrigues of the Cecils and the Seymours thwart her chances of a suitable match. Though she be nine years my senior, people say I resemble her and I know not whether to be sad or glad about the likeness. I have seen her once, and her face is beautiful, but I cannot forget the sorrow of loneliness in her eyes.

At fifteen, I have no wish to be as Arabella or Queen Elizabeth, with my fate determined by my status, yet the process has already begun. These last days of June, 1599, I have stood for a portrait which will be passed from hand to hand until a man I do not know, and have never seen, finds my looks passable enough to make an offer. Is it wrong to say I do not wish for such a husband?

I am dressed in dark, heavy clothes, which are deemed proper for a young lady of wealth, but do not become me. Their tightness robs me of breath, leaving me stiff and unsmiling, and my organ-pipe ruff and cumbersome French hood press my head forward. I look older and more timid than I am and do not recognise myself in this awkward person. How strange it is that my future husband, if he exists at all, will prefer a pale, solemn wife to a laughing girl who dresses brightly and shows her enjoyment.

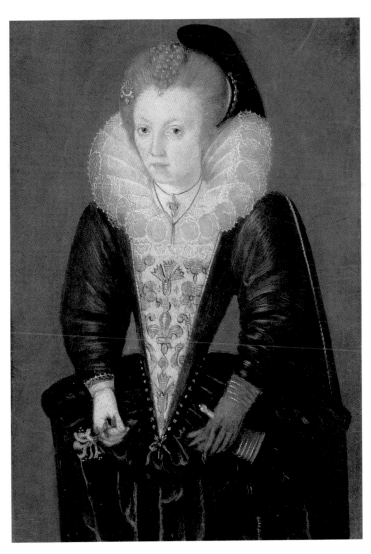

Unknown gentlewoman,
possibly Lady Arabella Stuart
(1575–1615), c.1595–1600

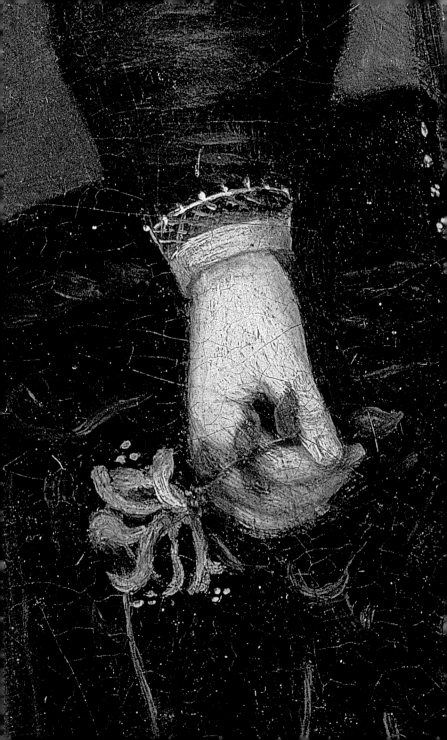

I am already in dread of him. A man who picks a wife from a parade of canvases will care nothing for her feelings. Once the offer is made, and the dowry exchanged, she will be as one of his horses, a creature only good for mounting. I see him in my mind's eye as old and fat like the Queen's father, King Henry: a tired, extinguished flame, so desirous of an heir that he must take a child bride to re-ignite his passion.

My heart is indeed heavy, for, were I allowed to choose, I would choose Master Ruccini who paints my portrait. He is young and handsome, and he whispers *ti adoro* when my nurse falls asleep on her stool. He will be gone when the summer is over, but he depicts me with a honeysuckle blossom in my hand lest I ever forget that a man once loved me for my company, and not for the displays of wealth and seriousness that his portrait seeks to contrive.

I fear loneliness, whether I marry or not.

MINETTE WALTERS

Opposite
The honeysuckle in the
woman's hand is possibly
meant as a symbol of love.

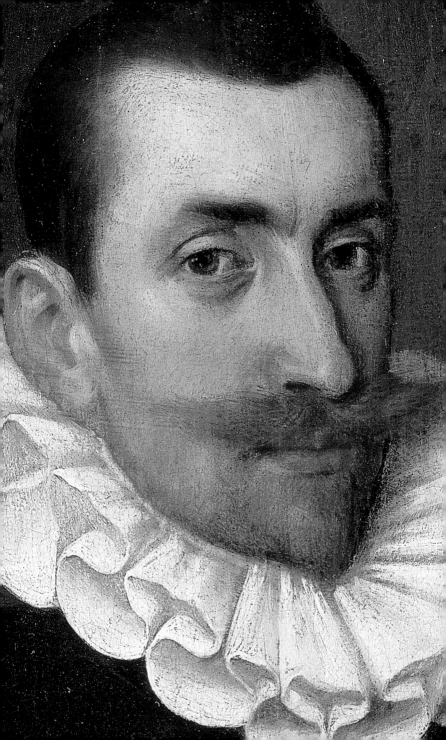

'Scholar, swordsman and sometime privateer; a composer and musician – a player of games.'

The Life of Nicholas Colthurst

Nicholas Colthurst: scholar, swordsman and sometime privateer; a composer and musician – a player of games.

The portrait was painted in 1601 when Colthurst was forty years old and at the height of his career. He is a striking, handsome man with a waxed moustache. His face expresses a guarded intelligence, confidence and ambition, but he is also something of a dandy. A pleasing jauntiness colours his calculating, masterful air.

Born in 1560, it is thought that Colthurst was the illegitimate son of a Protestant nobleman serving in the court of Elizabeth. His mother, Mary Colthurst, was a young servant at Elizabeth's court, but her son evidently enjoyed the support of his father: he was well educated by private tutors, adept with a rapier and excelled in music. As a young man he wrote a number of songs (three of which have survived) and in 1599, aged thirty-nine, was appointed Master of the Lord Chamberlain's Musicians, a ceremonial post acknowledging his passion and talent for music and composition.

As a young man Colthurst was an adventurer. His illegitimate status complicated the usual route into the court so, aged twenty, he signed up in Elizabeth's navy. He served under Sir Richard Grenville, who was admiral of a fleet taking settlers to establish a colony on Roanoke Island, off North America, in 1585. On the return voyage the following year, Colthurst played an important role in the raiding of towns on the Azores.

Later, Colthurst commissioned a ship on his own account from a base in the Caribbean, from which he organised several successful attacks on Spanish ships. An astute tactician, he

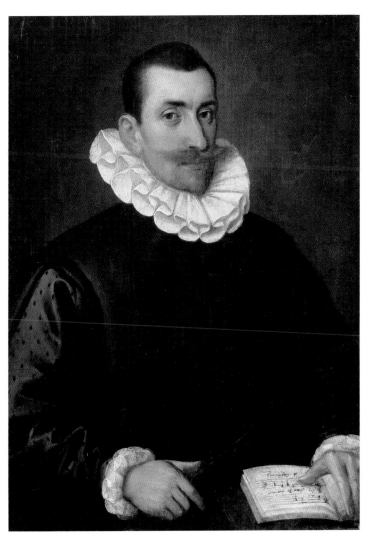

Unknown man, possibly John Bull
(1563?–1628), c.1600–20

returned to England with a significant contribution for Elizabeth's treasury, which served to expunge the shadow of his illegitimate birth and established him as a personage at the court.

Now, blessed with affluence and a respectable position, Colthurst married Jane Shawe in 1595, the youngest daughter of a wealthy spice merchant. They had seven children, two of whom died in infancy. Colthurst maintained his contacts in the navy; he was a cunning investor in the missions of privateers and, following his marriage, in the spice trade. He amassed a respectable fortune as a result. He enjoyed court life but maintained a discreet distance from court politics.

In his late thirties, Colthurst returned to his first love, music, and composed a range of songs, madrigals and dances. He was an accomplished player of the lute and virginal and published a popular collection of music and lyrics, *A Booke of Songes*, in 1603. The commissioning of the portrait reflects his assurance and status as a composer. He is carrying a conductor's baton and holds in his hand a piece of music.

Colthurst's music remained popular for a decade but gradually fell out of fashion in the court of James I. He retired to his family home in Somerset, where he lived with Jane and continued to make successful investments in the spice trade. His music continued to be popular in the county, and several surviving copies of his *Booke of Songes* have been discovered in the locality. He died in 1629, aged sixty-nine.

SARAH SINGLETON

Opposite
The lyrics on the musical score translate as 'I saw her, I love her, and I will love her'.

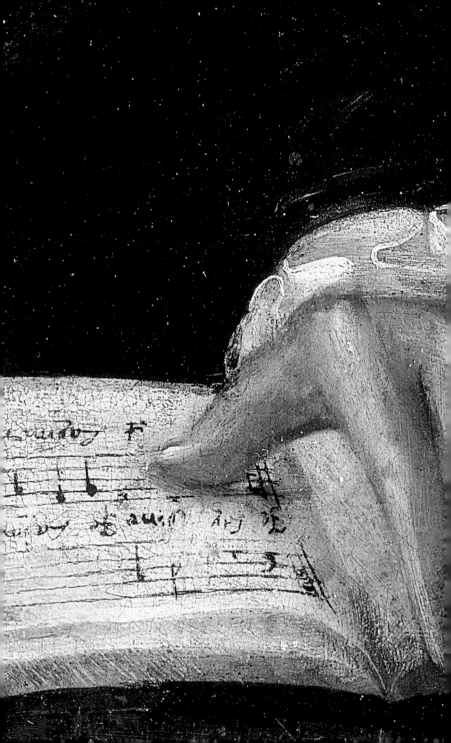

The Life of Edmund Audley Sarah Singleton

'Discretion was the hallmark of this minor official's life, in both the professional and private realms.'

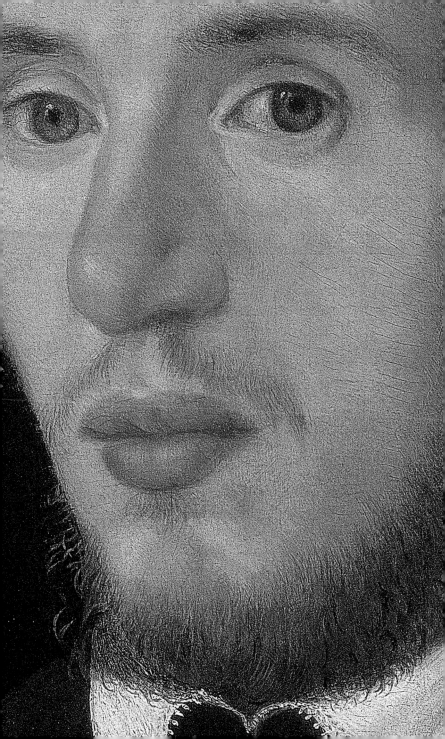

The Life of Edmund Audley

Edmund Audley was born in 1522, in Shoreditch, London, the second son of a wine merchant, John Audley, and his Flemish wife, Anna. An intelligent, sensitive boy, Edmund attended grammar school, and then Oxford University, where he studied the liberal arts – philosophy, poetry, rhetoric and arithmetic. Surviving correspondence indicates that Edmund showed little interest in his father's business, but he was diligent and ambitious. Aged eighteen, he secured a post as an under-secretary to Sir Richard Long, a member of the privy chamber for Henry VIII, which he retained until Sir Richard's retirement in 1545.

Edmund was reckoned to be discreet and industrious, a young man with an eye for detail and a keen understanding of human nature. Naturally reticent, he was also astute and articulate when the occasion called; he was promoted to secretary after a year, when Sir Richard was appointed governor of Guernsey, Alderney and Sark.

At the time of his retirement, Sir Richard secured a new post for his secretary, in the treasury. It seems Edmund reconnected with his mercantile roots, because he became adept in handling trade negotiations; he often travelled to Flanders, and in 1548 was posted abroad to represent the interests of the crown in the significant wool and cloth trade. Edmund lived between Flanders and London for several years.

In 1550, aged twenty-eight, he commissioned a portrait to send to his English bride-to-be, Margaret Mayne, the twenty-year-old daughter of a prosperous Cotwolds wool merchant. What did Margaret make of him? What did she learn from the portrait? Edmund has an air of reserve and intelligence; something about his face and expression suggest that he possesses integrity.

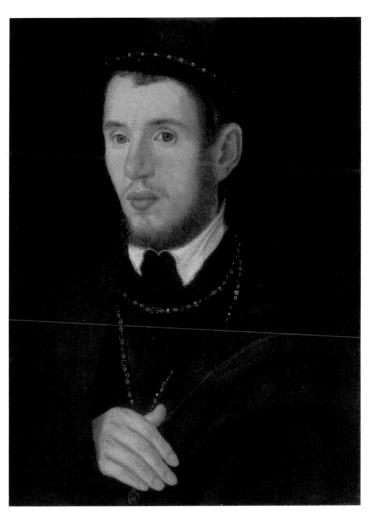

Unknown gentleman, formerly
known as Thomas Howard, 4th
Duke of Norfolk (1538–72), c.1560

He is modestly but well dressed with soft, elegant hands. For all that, he has a sensuous mouth, hinting at a more passionate side. Whatever Margaret read into the portrait, it seems she liked what she saw. The couple were married in 1551 and set up home in Northleach, Gloucestershire, though Edmund still spent a considerable amount of time in London and Flanders.

Life changed in 1553 when Mary ascended the throne. The Audleys were staunchly Protestant and the new regime brought sweeping changes. Edmund lost his post in the new Queen's Treasury and for five years lived a rather more circumscribed life with his wife. The couple had four children: Richard, Robert, Frances and Cecily. Documentary evidence suggests that he also helped his father-in-law, the wool merchant, though perhaps this new life in an English market town would have seemed limited after a career, even a minor one, at court and overseas. In any case, when Elizabeth replaced Mary in 1558, Edmund swiftly gained a new appointment at the Treasury, where he remained for nearly twenty years, working in a minor secretarial capacity.

He retired in 1577 due to ill health (he mentions a painful chest complaint in later correspondence) and spent the last three years of his life at home in Northleach. He died in 1580, at the age of fifty-eight. Margaret survived him by ten years.

Discretion was the hallmark of this minor official's life, in both the professional and private realms. Something about the attitude of his hand suggests the keeping of a secret – of holding matters close to the heart. Indeed, his portrait was commissioned in the same year as his marriage to Margaret Mayne – so why was it returned to Flanders? Perhaps a clue lies in a recent discovery, made during the renovation of the former Audley residence. A collection of elegant, intelligent but passionate poetry was found in a locked wooden box under Elizabethan-era

floorboards. The handwriting matches that on correspondence written by Edmund Audley and the poems are addressed to one Johanna. Did the respectable official harbour an intense, secret passion for a mistress in Flanders? Was she considered unsuitable for marriage, or did he meet her after making his matrimonial alliance with the Mayne family? Whatever happened, there is no evidence to suggest he returned to Flanders after 1553, so this enduring passion (dates on the poems suggest they were written over a number of years) remained a very private and painful concern for Edmund Audley alone.

SARAH SINGLETON

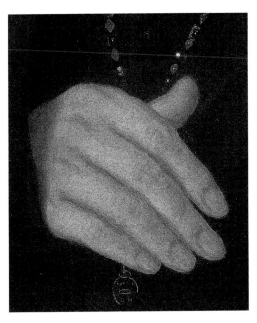

Detail of the man's right hand resting on his cloak.

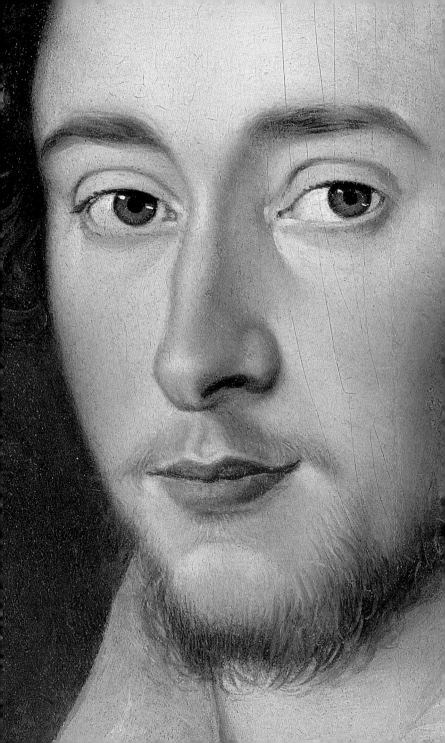

Rosy Tracy Chevalier

'Only George could call me Rosy. I would not allow anyone else.'

Rosy

I am still wearing the white brocade doublet Caroline gave me. It has a plain high collar, detachable sleeves, and intricate buttons of twisted silk thread, set close together so that the fit is snug. The doublet makes me think of a coverlet on a vast bed. Perhaps that was the intention.

I first wore it at an elaborate dinner her parents held in our honour. I knew even before I stood up to speak that my cheeks were inflamed.

I have always flushed easily – from physical exertion, from wine, from high emotion. As a boy I was teased by my sisters and by schoolboys – but not by George. Only George could call me Rosy. I would not allow anyone else. He managed to make the word tender. He said it described not just my cheeks, but my lips as well, smooth and crimson as rose petals.

When I made the announcement, George did not turn rosy, but went pale as my doublet. He should not have been surprised: it has been a common assumption that I would one day marry his cousin. But it is difficult to hear the words aloud. I know: I could barely utter them.

Caroline bent her head, the pearls in her smooth hair catching the light. Her eyes remained on her small, graceful hands folded in front of her. Her half-smile looked rationed. She has done nothing wrong.

Afterwards I found George on the terrace overlooking the kitchen garden. Despite drinking steadily all afternoon, he was still pale. We stood together and watched the maids cut lettuces.

'What do you think of my doublet?' I asked. George always noticed clothes. He glanced at me. 'That collar looks to be strangling you.'

'We will still see each other,' I insisted. 'We can still hunt, and play cards, and attend court. Nothing need change.'

George did not speak.

'I am twenty-three years old. It is time for me to marry and produce an heir. It is expected of me.'

George drained another glass of claret and turned to me. 'Congratulations on your upcoming nuptials, James. I am sure you will be content together.'

He never used my nickname again.

TRACY CHEVALIER

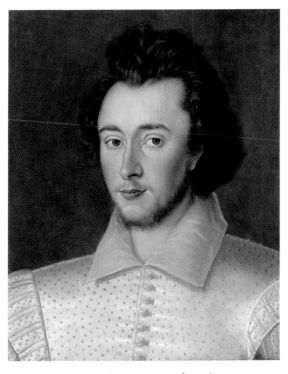

Probably Sir Robert Dudley (1574–1649), formerly known as Sir Thomas Overbury (1581–1613), c.1590

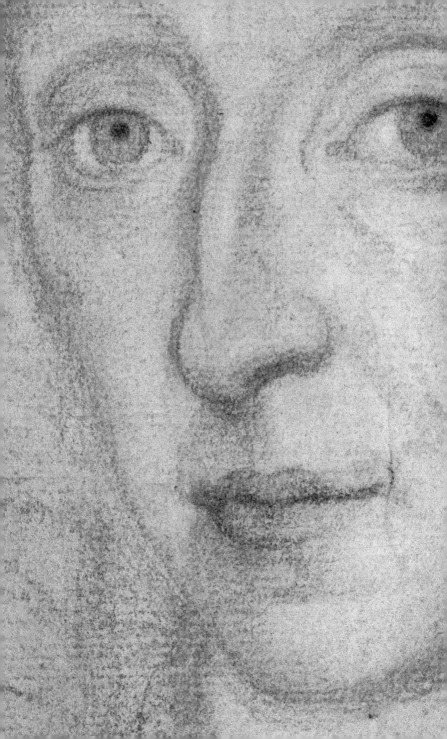

'It is just as well William has almost finished the drawing, for Death is impatient to visit again.'

A Hand on my Shoulder

I am not sure why I agreed to let William draw me. I certainly did not want a painting of me, not now. 'A drawing, then,' he said. 'That is all. One I can keep in my studio as a model for a dignified lady.'

Of course William was good friends with my husband, and has been so kind to me since his death, and my son's. But I could have put him off longer, said I was too full of grief, and too weak from my own illness. Perhaps I simply wanted the companionship of a man again, to sit with him and talk to him while he drew.

He let me see the drawing today. Though he has done his best, William is too honest. He did not hide how thin I look, the flesh melted from my cheeks, my brow so bony. And something has happened to my eyes. The fever has made them lighter, if that is possible. I cannot seem to hide my thoughts – sadness and fear brim in my eyes like tears. The hand of Death has been heavy on my shoulder, and left its mark. I still feel its weight, though it is now only a ghost – a ghost waiting to return one day.

To distract others from my ravaged looks, I have worn my widest collar and the topaz necklace Henry gave me after Harry's birth. 'Good girl,' he'd whispered as he hung it around my neck. 'Well done.' Now he and Harry are gone, leaving my daughter and me alone – a household of women in a world of men, waiting to see what will happen to us.

Yesterday Henry's brother appeared, narrowing his eyes at William and insisting that my daughter and I were expected at his home for dinner. He fears any man who comes close to me, thinking they are sniffing my late husband's estate. He would not have me marry again, if it means his family is to lose Henry's wealth to

another. Better instead to march us across the cold fields, to dine with him and his wife in a draughty hall before an indifferent fire.

His little plan has had its effect. Already I feel a familiar pain behind my eyes and a hand scratching in my throat. It is just as well William has almost finished the drawing, for Death is impatient to visit again.

At least my daughter is healthy.

TRACY CHEVALIER

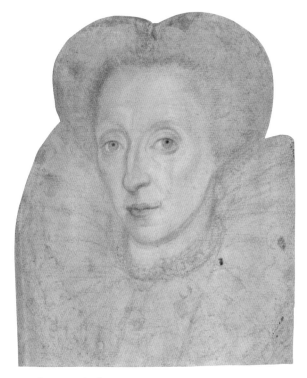

A pattern for a portrait of an unknown noblewoman, possibly Queen Elizabeth I (1533–1603), c.1595

'My nose has about it a shine and a hint of colour which would indicate a propensity to being fuddled.'

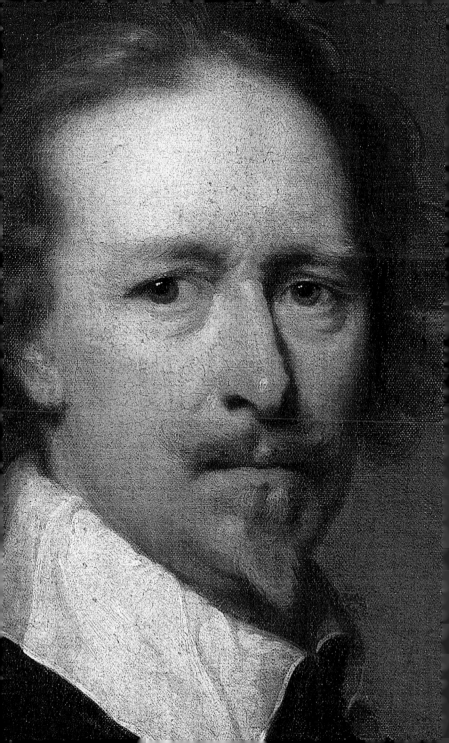

From the Diary of Paxton Whitfield

Gentleman, of Mountsteven in the County of Cornwall,
on this day, May the twentieth, in the year of our Lord, 1636

This day was my likeness completed. I am at last well satisfied. I had much argument with the painter, who would not have me stand with my left hand towards my breast, saying that such a gesture was reserved for artists alone, when portraying themselves. But I held my ground in the matter. Indeed, I am known for holding my ground.

I am painted in my new black damask. It was exceeding costly, having to be thrice dyed to gain the depth of blackness that would satisfy me. I have also a falling collar in fine linen, but no other adornment, no sword belt, no seal upon my finger. I wish to stand as myself, for myself. I have no need of symbols.

Perhaps I am a little taken aback in the matter of my nose. My mouth is as I would wish, firm and well shaped, and my brow displays the breadth of a man of education and culture, such as I am. But my nose has about it a shine and a hint of colour which would indicate a propensity to being fuddled. I am, in truth, seldom fuddled, and never without severe provocation. I remonstrated with the painter, but he did merely say, over and over, that he painted what he saw with all the fidelity his skill could bring to bear. He told me that I had prevailed in the matter of my left hand, and that I should be content with my nose. I fear it must be so, for fear of incurring even greater expense.

I shall hang the painting in my library. I know the exact spot, upon the wall directly opposite the door, where it will immediately strike all those who enter. In her shrewish way, my wife has suggested that I might like to place a small table beneath, for candles, and offerings in tribute, but I feigned not to have heard her. She liked my looks well enough when we were wed, but custom has staled her admiration. And her courtesy.

I say again, I am on the whole well satisfied. It is something indeed, for a man to possess his own likeness. When I look upon it, I have the sensation that indeed I have my place upon the earth, and that place is manifest for all to see. It would be a joyous thing were my wife to be of like mind, but she prefers to make sport of everything that signifies to me. Including, it grieves me to say, this likeness.

JOANNA TROLLOPE

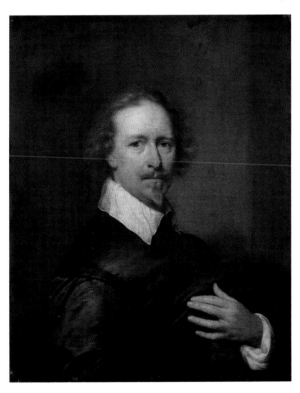

Unknown man, formerly thought to be a self-portrait
by Cornelius Johnson (1593–1661), 1636

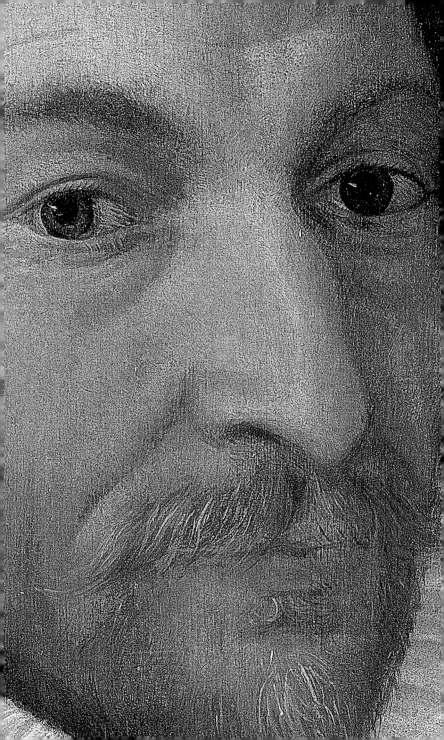

A Letter from Catherine Hartshorn Joanna Trollope

'Firm mouth.
Is this a man
of decision?
Or a man of
short temper...'

A Letter from Catherine Hartshorn

A.D. 1587, February 2nd

To my right worshipful mother, Elizabeth Hartshorn.

Right worshipful mother, in my most humble wise, I
recommend myself to you, beseeching you of your daily blessing.
And, mother, I would fain you would return home. I am in sore
need of your good counsel, and know not which way I should turn.

I have, this day sennight, received a proposal of marriage from
Edmund Newton, enclosing his portrait, which he says will plead
his cause better than he could himself. I have had this portrait in
my chamber these past seven nights, and I am so overwrought
with looking upon it that I know no longer what to think, only
that I should be so glad to have you here to guide me.

He tells me he is thirty-two, above a dozen more years in age
than I am, which I am sure you will tell me does not signify. His
complexion is clear, his eye blue and acute, his hair and beard
reddish, which gives me to think him of Scots extraction and
thus not ready to be too open with his purse.

He wears a very fine doublet, beloved mother, dull violet in
colour, striped in a velvet ribbon with picot edge, and his ruff
is well stiffened and of a good whiteness, indicating good
laundresses at Newton Hall, which pleases me. And in his hand,
he holds two pinks, one white, one crimson, which he tells me
he had painted to show me he is in earnest about this marriage,
for my own person, as well as because his land and that of my
worshipful father do march together so conveniently.

And, mother, there is a coat of arms too, a black and gilded
helmet with plumes, above a shield of red and white chevrons,

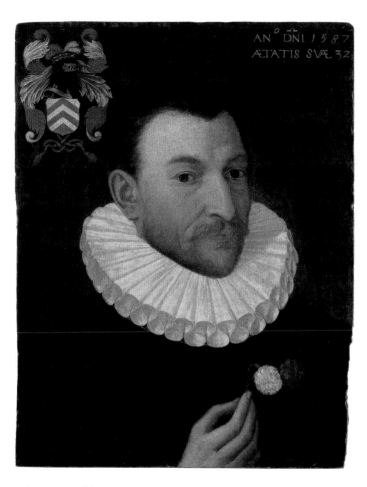

Unknown man of the Van
Nierop family, formerly known
as John Gerard (1545–1612), 1587

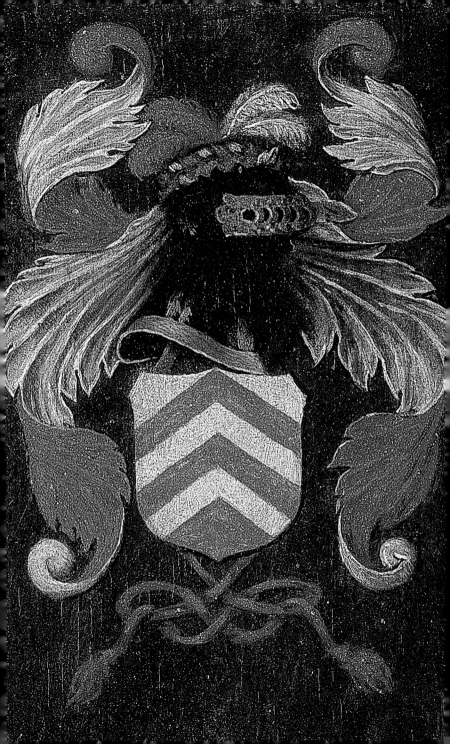

and I need you to advise me if this is a true indication of his status, or if, as I have oft heard you say, it is merely the invention of one who wishes to be better placed in society than he is?

Most especial good mother, I am in a confusion. I look upon the portrait and I think, 'Firm mouth. Is this a man of decision? Or a man of short temper ...' I think, 'Trimly cut hair and beard. Is this a man of refinement? Or is this a man over given to discipline in details ...' I think, 'An aquiline nose. Is this a man of good humour? Or a man who will not tolerate to be disobeyed.' At least, mother, I can contemplate his ears without disquiet. They are unexceptionable ears.

In short, worshipful mother, I believe this to be a good likeness. But – do I like the likeness? I can decide nothing till you shall come again home which I beg you to do with all dispatch.

At Hartshornsford, this day of Candlemas.

With the hand of your dutiful daughter,
Catherine

JOANNA TROLLOPE

Opposite
The coat of arms has been
identified as belonging to
the Van Nierop family.

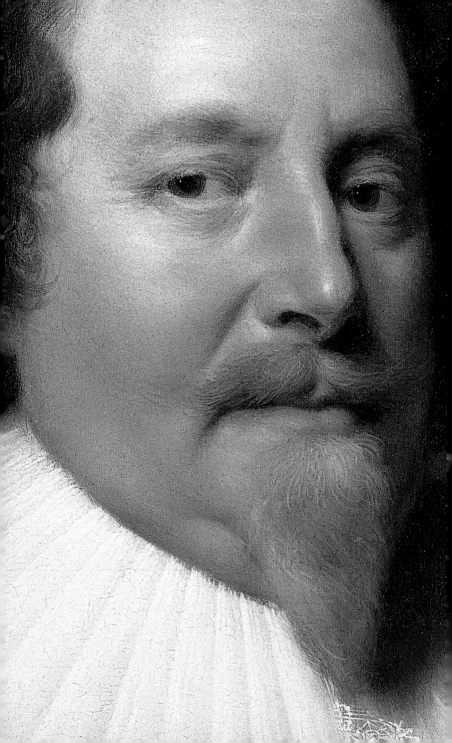

The Biography of William Wrightson Julian Fellowes

'Kill him now,
I beg you, for
I may not.
Methinks my
wife would
mislike it.'

The Biography of William Wrightson, 2nd Viscount Dorchester

William Wrightson, 2nd Viscount Dorchester (1594–1659), was the second but eldest living son of John Wrightson, 1st Viscount and Chancellor to King James I, who raised his servant to the peerage in 1609. William passed his early years principally at his father's house, Cobblers, near Esher, and at Wrightson House in Chelsea, where he was under the instruction of the prelate Philip Sackville, later appointed to a bishopric by Archbishop Laud and subsequently executed by Oliver Cromwell for his papist sympathies. William had been intended for the Church, but the death of his elder brother, Francis, in 1607, of a fever contracted while playing real tennis with Prince Henry at Hampton Court, altered his prospects, presumably for the better, since he is on record as saying that he 'did detest the Church for a profession above all things, and that to include hangman and rat-catcher'.

The first Lord Dorchester did not live long to enjoy his honours, dying in 1615 of a palsy and leaving William and his sister, Joanna, the sole survivors of a family of ten. These two had earlier contracted a double marriage with the 4th Earl of Cumnor and his sister, Lady Mary Norrys, which was to divide the family most unhappily. When Charles I raised his standard at Nottingham in 1642, Dorchester declared for the King without hesitation, but Cumnor hung back, finally joining the forces of Parliament in time for the decisive Battle of Naseby. Their wretched wives were both obliged to see husband and brother at war, a predicament cruelly underlined by Cumnor's calling out, on seeing his brother-in-law in the thick of the fighting, 'There goes my Lord Dorchester. Kill him now, I beg you, for I may not. Methinks my wife would mislike it.'

In the event, both peers lived through the struggle, but while Cumnor had profited from Cromwell's triumph and went on to take

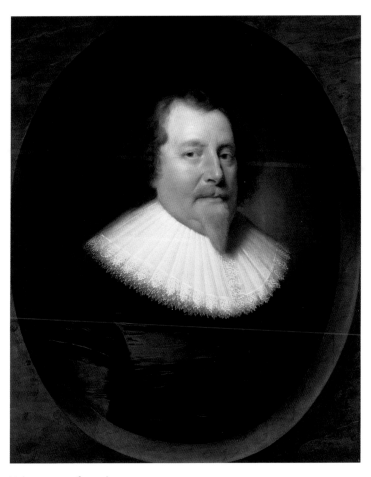

Unknown man, formerly
known as Richard Weston,
1st Earl of Portland
(1577–1635), 1627

Overleaf
Detail of the unstarched
'falling ruff' and black
silk doublet.

a leading role in the Commonwealth, Dorchester, much reduced in circumstance and the subject of heavy fines, retired from the world to devote himself to the study of flora and fauna. His work *Ye Bestes and Pastures of our Noble Lande* remains the definitive seventeenth-century publication on the subject, while several species, principally the butterfly *Heliconius wrightsoniae* and the rare speckled field mouse, *Apodemus wrightsonicus*, are testimony to his ground-breaking research in this field.

Renewed persecution in the 1650s, possibly inspired by his brother-in-law, led to a decision to join the young King-in-waiting in his temporary French exile. This Dorchester accomplished in 1653, at the advanced age of 59, by posing as a deckhand on a ship carrying tin to Le Havre, an imposture almost uncovered by the harbourmaster, who observed that Dorchester had 'a passing smooth face for a varlet', but the captain, who knew Dorchester's identity, created a distraction and the danger passed. Dorchester's wife joined him some months later, having effected her escape in the train of Cromwell's daughter, Lady Fauconberg, already suspected of Royalist sympathies, who would later figure at the court of Charles II. This Lord Dorchester would not do, since he died in the Netherlands in 1659, at the great age of 65, swearing his unswerving loyalty to the Crown, an oath which earned his widow a royal pension on the Restoration the following year. Their grandson, the 4th Viscount, would later serve in the armies of King William III, in his continental wars against the Grand Monarque, earning himself the sobriquet of 'Dauntless Dorchester'.

In this portrait, probably painted during Janssen's stay at the English court from November 1634 to February 1636, Dorchester wears a 'falling ruff', so called as it was worn unstarched. His plain clothes are a further rebuttal, if one were needed, that not all Cavaliers wore colours, and not all Roundheads confined themselves to black.

JULIAN FELLOWES

'False King, false Church and now false wife, I am thrice cursed!'

Blanche Vavasour,
Lady Marchmont

(1497–1558)

Blanche Vavasour was the second daughter of Sir Richard
Vavasour, Treasurer to Princess Katherine, Countess of Devon,
and aunt to King Henry VIII. Blanche spent her childhood in
the Palace at Greenwich and at Rottingham Place in Claygate,
the home of her mother's family, the Lovells. In 1514, she
married the 4th Lord Marchmont and, in 1516, was appointed
to the household of the infant Princess Mary, a position later
lost with the demotion of the Princess to bastard in 1533.
Blanche's husband, Edward Marchmont, was a protégé of the
Chancellor, Sir Thomas More, which brought him early royal
favour, but afterwards disgrace when Marchmont criticised the
King for his role in More's downfall. This led to his arrest for
treason after the execution of Sir Thomas in 1533. Blanche, his
wife, enlisting the support of the Courtenays, submitted a petition
for mercy, as a result of which King Henry offered Marchmont
freedom in return for his oath to the Act of Supremacy.

When Marchmont wrote to the King from the Tower refusing
to swear, Blanche intercepted his letter and instead delivered
one, forged by her own hand, agreeing to the King's terms.
On receiving it, Henry gave the order for Marchmont's release,
but when the husband returned to his home and discovered the
intrigue, he uttered the only words of his which have descended
to us: 'False King, false Church and now false wife, I am thrice
cursed!' This being reported to the King, the order for Marchmont's
re-arrest and execution was issued and the sentence summarily
dispatched. There is some evidence that he sent a message to

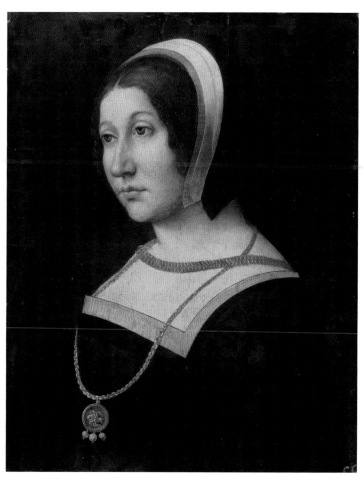

Unknown noblewoman,
formerly known as Margaret Tudor
(1489–1541), c.1520–40

Overleaf
Detail of the pendant showing
a horseman with a hawk being
chased by the figure of Death.

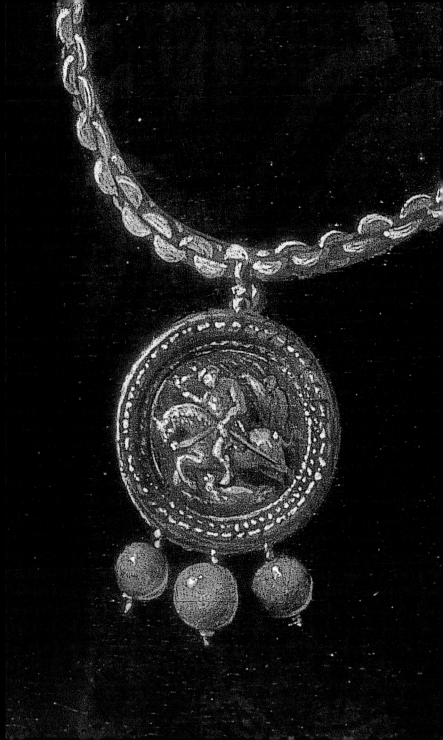

his wife begging her forgiveness, but this may have been an invention of the nineteenth-century historian C.W. Bradley, since no other writer has seen the papers on which the account is based.

This portrait appears to have been commissioned to commemorate Blanche's sorrow. Dressed in widow's weeds, she wears a downcast look as well as a distinctive brooch, as witness to the tragic death of her husband, to whom she appears to have been defiantly loyal. The image is that of a horseman with a hawk – a clear reference to Marchmont, who was a keen hawker – being chased by the figure of Death. The three pendant pearls were perhaps symbolic tears representing his famous Triple Curse, implying that Blanche must have accepted his judgement of her actions.

Blanche did not remarry, instead spending much of her time trying to rescue her husband's property which, as belonging to a traitor, had reverted to the Crown. She also attempted to reverse the judgement that denied her husband's rank and title to their eldest son. The King was not merciless. He had known Blanche from a child and may have been more sympathetic to her predicament after the execution of Anne Boleyn in 1536, as the Queen had been the Marchmonts' implacable enemy. In 1542, he restored to Blanche the house and estate known as Folleys Court, near Guildford, and she seems to have spent her last years there. The attainder was eventually lifted, but not until after her death, when Queen Elizabeth rewarded Blanche's son, Thomas, for a successful embassy to the French court in 1561. Thomas, 5th Lord Marchmont, died in 1587 without issue, and the title became extinct.

JULIAN FELLOWES

'Stabbed in the throat by an unknown assailant.'

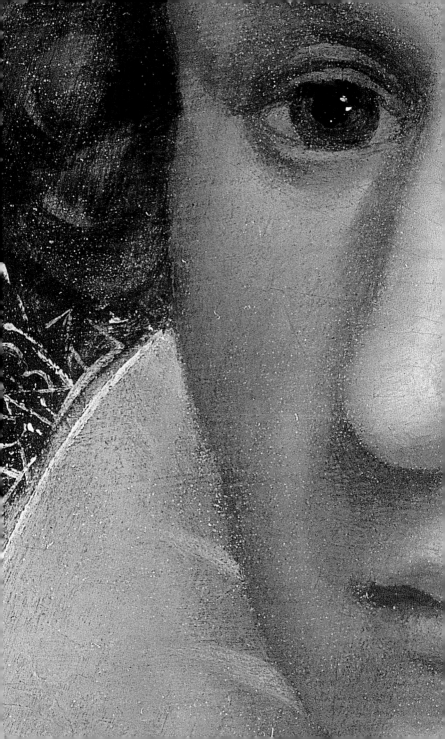

The Life of Joachim Müller

Joachim Müller, scholar, scientist and probable spy, was born in
Regensburg in 1576, the illegitimate son of an itinerant preacher
who, according to some sources, was an Englishman. Maria
Müller, Joachim's mother, a maid in the service of the Thurn
und Taxis family, was obviously a forceful woman, for despite
her lowly status she managed to send her son to the University
of Wittenberg, where he distinguished himself in the study
of natural science.

Among his correspondents in his Wittenberg days was the
astronomer Johannes Kepler, whom Müller is known to have
visited in 1596 at Graz, when Kepler was Professor of Mathematics
at the university there. Müller became an enthusiastic proponent
of the new, Keplerian cosmology based on Copernicus's theory
of a sun-centred universe. It may have been at Kepler's invitation
that in 1603, Müller travelled to Prague, where Kepler had
succeeded Tycho Brahe as Imperial Mathematician to the
Emperor Rudolf II.

Rudolf, eccentric, secretive and melancholic, had a deep
interest in science, particularly those areas where mathematics
shaded into numerology and chemistry into alchemy – he kept
dozens of alchemists on permanent service in Golden Lane,
under the shadow of Hradcany Castle. Among them, for a time,
were the English mage John Dee and his disreputable associate
Edward Kelley. Müller too worked for a time in Golden Lane,
though hardly on the recommendation of Kepler, who had
little time for the dark arts.

In the winter of 1610 Müller made a hasty departure from
Prague following a scandal involving one of the ladies at court

Unknown man, possibly William
Drummond of Hawthornden
(1585–1649), c.1610

– details of this affair are scant – and he is next heard of the following spring in London, at the court of James I, where he presented himself as an unofficial ambassador sent by Rudolf to treat with the English king. It is unlikely that the Emperor would have chosen such a man for so delicate a mission. Popov, in his monograph on Müller, suggests that Müller was a spy for Rudolf's younger brother Matthias, who opposed Rudolf's extreme Catholicism and allied himself to the German Protestants. It is possible that Müller acted as a go-between in the negotiations that would lead in 1613 to the marriage of James's daughter Elizabeth to Frederick V, Elector Palatine, the so-called Winter King and champion of the Protestant cause in Europe.

Whatever the reason for Müller's London sojourn, it came to an abrupt end on Guy Fawkes Night, 5 November 1612, when he was waylaid in a street near to the Tower of London and stabbed in the throat by an unknown assailant. Rumour at the time had it that his death had been ordered by Rudolf's supporters, although the Emperor himself had died the previous January, to be succeeded by Matthias. The whereabouts of Müller's grave is not known.

JOHN BANVILLE

Opposite
Detail of the left eye. The awkward positioning of the eyes suggests the artist may have found the half-profile position challenging.

The Life of Launcelot Northbrook John Banville

'Half the women
of London went
into mourning
when he married
Penelope Bright.'

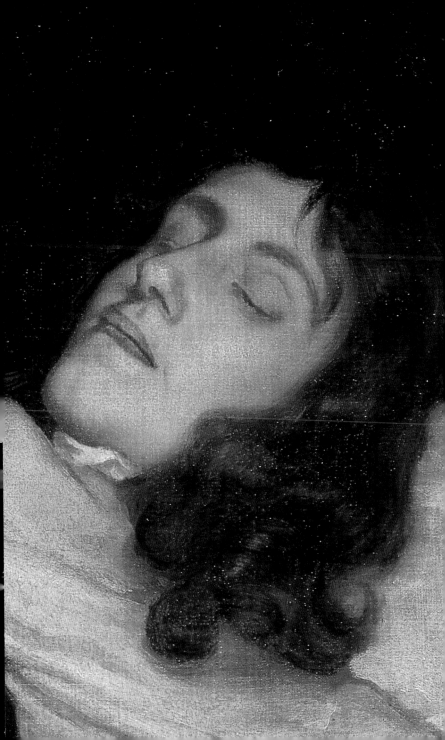

The Life of Launcelot Northbrook

Launcelot Northbrook was born at Chester in 1621. His father,
Andrew, was a successful printer with premises on Lower Bridge
Street nearby the Castle; his mother Margaret, née Poole, was the
daughter of a yeoman farmer with lands beyond Christleton.
Launcelot received a grammar school education and at the age
of fifteen entered Sidney Sussex College, Cambridge.

Already as a boy Launcelot had shown a marked skill as a versifier,
and a chapbook of his poems printed at his father's shop is dated 1635.
The poems in this modest collection, notably 'Lines on the Martyrdom
of Saint Sebastian', display a fair knowledge of Latin and Greek forms –
the stirring 'Antony's Fall at the Battle of Actium' is cast as an Horatian ode.

It was probably at Cambridge that Northbrook first heard Oliver
Cromwell spoken of – Sidney Sussex was Cromwell's college – and it is
known that some time shortly after graduation he visited the future Lord
Protector at his farm at Huntingdon; Northbrook's poem 'To O.C. Esq.
on the Occasion of His Entry upon Parliament' is one of the first works of
what may be called the poet's maturity. He was also acquainted with John
Milton, and may have acted briefly as his amanuensis: an early copy
of Milton's pamphlet *Apology for Smectymnuus* is believed by some
scholars to be in Northbrook's hand.

Northbrook was renowned as one of the most handsome men of
his generation – his auburn locks in particular were much admired –
and the saying was that half the women of London went into mourning
when, in 1643, he married Penelope Bright, the daughter of one of
Cromwell's cousins. In 1645 or 1646 the couple had a son, Andrew, and
a daughter, Elizabeth, was born in 1649. It is thought that Northbrook
never saw this daughter, for by the time that she was born he was in
Ireland serving as a staff officer with Cromwell's New Model Army.

At the siege of Wexford by Roundhead forces on 11 October 1649, Northbrook was with the Army command at its camp on elevated ground at the southern end of the town – an area known to this day as Cromwellsfort – where he was grievously wounded in the left temple by a musket ball from a Confederate gun and died the following day. His body was transported back to England, and was buried in the south aisle of Chester Cathedral, although his grave is no longer marked. The deathbed portrait by Kneller is a fanciful imagining, perhaps executed at the behest of Northbrook's widow.

JOHN BANVILLE

Unknown man, formerly known as James Scott,
Duke of Monmouth and Buccleuch (1649–85), c.1640

The Tale of Joshua Easement Terry Pratchett

'He is a man
born under
the wrong stars,
and has never
learned which
ones they are.'

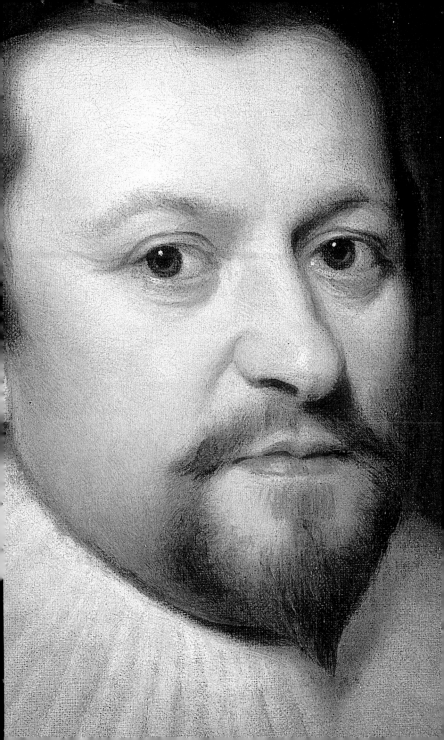

The Tale of Joshua Easement

Sir Joshua Easement, of Easement Manor, Shrewsbury, was, in his own estimation at least, one of the last of the old Elizabethan seadogs – an ambition that was somewhat thwarted by a total lack of a grasp of the principles of navigation. Documents in the National Maritime Museum reveal that Sir Joshua's navigational method mainly consisted of variations on the theme of bumping into things, and this was exacerbated by his absolute blindness to the difference between port and starboard. It was a joke among those seafarers who were lucky enough to have sailed with him and survived, but this was because he had never drunk starboard, but had drunk practically everything else. Such of his papers that survive give a tantalising hint that in failing to discover the Americas, he may nevertheless have discovered practically everywhere else. What can we make of the hint of a land of giant jumping rats, found in the southern oceans, but – owing to Sir Joshua's record-keeping – lost the following day?

Nevertheless, quite late in the reign of Elizabeth I, he succeeded not only in finding the Americas, but also in finding England again. He then, with much ceremony, presented to Good Queen Bess a marvellous and intriguing animal from that far-off country whose black-and-white fur he deemed very attractive and fit for a queen.

It was at this point that the court really understood that in addition to only a nodding acquaintance with the concept of direction, Sir Joshua had no sense of smell whatsoever. This led to the Queen, despite her growing infirmities, going on progress again at quite a high speed. When frantic courtiers asked about the destination she said, 'Anywhere away from that bloodye man.'

Nevertheless, even as relays of servants were scrubbing the palace floors and the female skunk was giving birth in the cellars, the Queen

gave Sir Joshua the office of Captain of the Gongfermours or, in other words, in charge of the latrines, a post for which he was clearly well suited. Oblivious to the sniggers of the other courtiers, he took this position extremely seriously and even adopted on his coat of arms the motto *'Quod Init Exire Oportet'* (What Goes in Must Come Out).

John Dee said of him: 'He is a man born under the wrong stars, and has never learned which ones they are.'

Dogged to the end, and oblivious to the noxious gases that only he could not smell, he spent the last years of his life in the following century trying to find a way to harness their igniferous nature, achieving an overwhelming success that led to his hat being found in Kingswinford and his head being found in a bear pit in Dudley.

TERRY PRATCHETT

Unknown man,
formerly known as
Sir Ralph Winwood
(1562/3–1617), *c.*1620

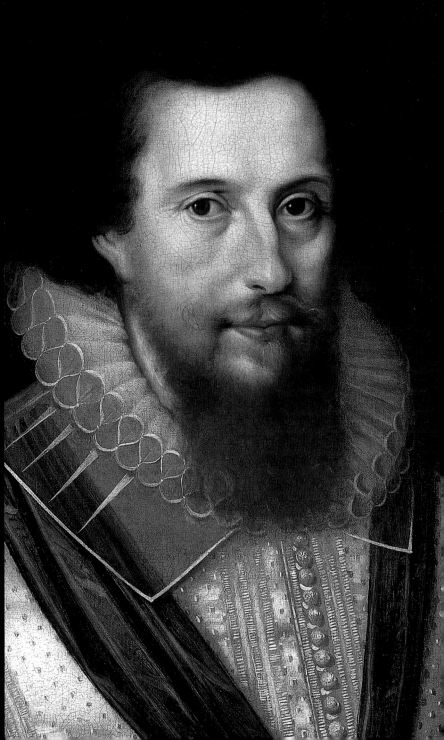

Did my hero look like that?
Identifying sitters in historic British portraits

TARNYA COOPER

A visit to almost any art gallery will involve an encounter with
a portrait of an 'unknown' man or woman. The faces of these
portraits may be unrecognisable, but they remain intriguing
and often touching documents of past lives. Hanging alongside
portraits of identified people on the gallery's wall, these 'unknowns'
seem like lost souls whose quest for immortality has proved only
partially successful. Although their faces can still be seen, their
names, reputations and deeds are not recorded. As the last trace
of men and women who once lived and had similar concerns to
ourselves – about everything from family relationships to personal
appearance – these portraits are poignant reminders of our own
mortality and offer lessons in our own desires for a lasting legacy.
At the most basic level they record the intention of an individual
to share his or her likeness with family, friends and peers. In the
sixteenth and seventeenth centuries people commissioned
portraits for all sorts of reasons, including the commemoration of
occasions such as marriages, births or awarded honours. However,
simple opportunity, such as the encounter with a talented artist,
may also have been the impetus for commissioning a portrait.
As paintings, these images of unknown sitters are often examples
of highly accomplished works of art. Indeed, as the pictures
in this book clearly show, it was perhaps their status as pleasing
art objects that ensured their survival, as past generations have
presumably housed, cared for and displayed them primarily for
their aesthetic and historical value.

Many portraits, both within museums and in private
collections, remain unidentified. The National Portrait Gallery's
postbag bulges with requests to help identify the people depicted
in historic portraits. How is it possible to do this, and with what

Opposite **Robert Devereux, 2nd Earl of Essex** (detail of NPG 180, see page 89)

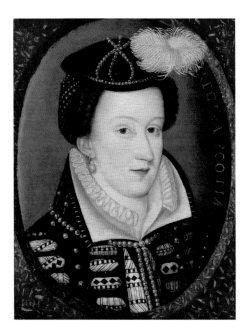

Mary, Queen of Scots
Unknown artist
Oil on panel, *c.*1560–92
251 x 191mm
NPG 1766

certainty might a portrait be identified as, say, Henry VIII, Oliver
Cromwell or Mary, Queen of Scots – or, conversely, of less famous
people such as courtiers, poets, soldiers, statesmen, physicians or
artists? We might imagine that identifying portraits of well-known
rulers is straightforward because numerous authentic portraits
exist for comparison. And yet, as the example of the possible
portrait drawing of Elizabeth I (page 45) shows, identification
is not always clear-cut. Several factors can help to confuse the
identification of portraits of monarchs, such as the lack of evidence
for appearance early in life (as with Henry VII and Henry VIII), or
the desire of wealthy courtiers to model themselves on the monarch
in their costume and hairstyle as a form of flattery (as was the
case at the courts of both Elizabeth I and Anne of Denmark).

In a period before photographic reproduction allowed for easy
comparison, the practical identification of portrait sitters was
extremely difficult. Part of the problem was the overzealous

enthusiasm of eighteenth- and nineteenth-century owners, collectors and historians to apply specific labels. Such interested parties were often quick to make assumptions about the identities of early portraits on the basis of limited knowledge. For example, there was a misconceived assumption that portraits were only commissioned by monarchs and elite courtiers, yet by the mid-sixteenth century increasing numbers of wealthy country gentry, city merchants and lawyers as well as scholars and writers were also choosing to commission their likeness. There was also a lack of knowledge about trends in costume or portrait styles, and thus, regardless of date, origin or particularised appearance, portraits of elaborately dressed women might be routinely labelled 'Elizabeth I', 'Mary, Queen of Scots' or 'Anne of Denmark'. The example of Mary, Queen of Scots (opposite) is interesting, as her popularity and reputation increased in the centuries after her trial and execution for treason in 1587, stimulating a desire for posthumous portraits as a result of her growing status as a Roman Catholic martyr. However, the many portraits that once carried her name often bore no resemblance to her existing authentic portraits. Once applied, labels were often hard to challenge, and there may well have been financial advantages for owners in maintaining identities.

One example of a remarkable and striking portrait that has lost its identity and has long been associated with Mary, Queen of Scots (despite bearing no resemblance to her authentic portraits) is that of a female courtier dating from the 1570s (page 11). The portrait was purchased by the National Portrait Gallery in 1860 as an authentic likeness of the Scottish queen. The original identification was given authority by a coat-of-arms (now removed) hanging on a tree, which once purported to show Mary's heraldry at the time she was married to Francis, heir to the French throne. However, the coat-of-arms and several other elements of the picture were subsequently shown to have been later additions, and it seems likely that some time in the nineteenth century parts of the picture were doctored in order to manufacture a more convincing likeness of Mary, either for reasons of financial gain or to further Mary's status as a beautiful and tragic martyr. The later

additions were all removed in 1975 and what is left is a highly unusual portrait of an elaborately dressed woman against a mountainous landscape background with a castle to the right. We know little about the original sitter, but the painting is certainly English. It can be dated on the basis of costume to the 1570s, and the woman wears clothes suitable to a wealthy member of the nobility. The unusual black and white dress and the several pendant timepieces may relate to a heraldic scheme, but without further information her identity remains a mystery. One question is whether the painting is a portrait at all, or whether it might possibly have been painted as a personification of, for example, 'Youth' or 'Temperance', perhaps as part of a group of female worthies. However, her facial characteristics, including bright blue eyes, a long narrow nose and blond wavy hair, do present a highly individualised appearance. It therefore seems more likely that the painting is a portrait of a woman who employed the emblems of timepieces to signal her awareness of human mortality and hope for Christian salvation, or another more complex interpretive programme now lost to us. Further investigation into this picture is hindered by the fact that it is in poor condition and has suffered from a drastic physical intervention causing paint loss prior to its purchase by the Gallery.[1]

Another general factor causing confusion in identifying portraits of monarchs is that many surviving examples of royal portraits were not based on sittings from the life, but were often copied from each other. Often, many different versions of the same basic portrait type exist, as is the case with portraits of Elizabeth I, whose later portraits and posthumous portraits became emblems rather than likenesses. Thus, in these cases the question is not whether a portrait *depicts* a monarch, but whether it *represents* them. A process of visual 'Chinese whispers' can take place, with each portrait differing subtly from the last, as can be seen in the example of these two portraits of Anne Boleyn (c.1500–36, opposite), both of which are posthumous, based on a lost prototype. However, in most cases the accurate identification of portraits of rulers and consorts is possible. Indeed, some rulers

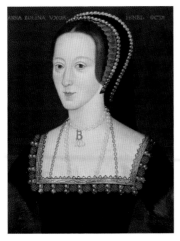 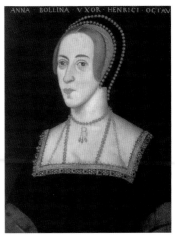

Anne Boleyn
Unknown artist
Oil on panel, late sixteenth century
543 x 416mm, NPG 668

Anne Boleyn
Unknown artist
Oil on panel, c.1590–1610
564 x 441mm, NPG 4980(15)

became associated with a distinctive facial appearance or particular poses, as with Henry VIII's small eyes, bullish appearance and wide stance, or Oliver Cromwell's armour and prominent nose.

Identifying portraits of courtiers, statesmen and many others who attained notoriety in the sixteenth and seventeenth centuries presents numerous challenges. As with the example of Mary, Queen of Scots, some charismatic and well-known figures from history have been serially misidentified. This is the case with Robert Devereux, 2nd Earl of Essex (1566–1601, page 89, left), a favourite of Elizabeth I who ultimately led a rebellion and was executed as a traitor. His charismatic personality and fashionable persona ensured numerous followers and also helped to set a trend among a circle of creative and ambitious young men for longer hair, the wearing of single earrings and sometimes an open-neck shirt. Therefore, many portraits identified as Essex were done so on the basis of eighteenth- and nineteenth-century myth-making and have since been proved not to represent him.

Unfortunately, in the case of far less-well-known members of the nobility, gentry and private citizens the task of identification is often extremely problematic. Once a picture loses its link with a family collection or an identifying label, the stitching of those details back together proves virtually impossible. If there are no other authentic portraits of that individual, the portrait is destined to remain with an 'unknown' label. How historic portraits might lose their identity, or become disassociated with the name of the original sitter, is a particularly pertinent question with regard to portraits of private citizens. From the relative security of the present day it is easy to forget that in the past, turbulent events, widespread illness, re-marriages, family disputes and early death frequently meant that families were truncated, dispersed and their possessions sold or abandoned. This was particularly true of non-noble families who did not have a permanent landed estate to harbour their goods over many generations. In fact, it is easy to see how within three or four generations family links between the original sitter of a portrait and his or her ancestor might have been lost and become meaningless.

So, how are the portraits we see hanging in galleries identified and how far can we trust their labels? Portraits can be identified in several different ways, including the evidence of origin (or provenance), such as documentary sources, comparison of a likeness with authentic portraits of a particular person, labels and inscriptions, along with an assessment of other supporting evidence such as date, costume and who the artist was. Successful identification will rely on the corroboration of several of these factors in order to make a secure identification. Within collections of family paintings it is not unusual for portraits to be misidentified as the most famous member from a particular time period, particularly when there are several generations of the same family with the same name. In the case of the portrait purchased by the National Portrait Gallery in 1933, identified as the Jacobean courtier Sir Thomas Overbury and later considered to be misidentified (see page 41), recent research into the provenance proved critical. The portrait had been part of a collection of paintings owned by

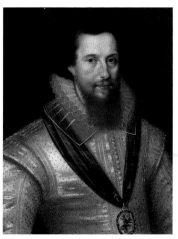

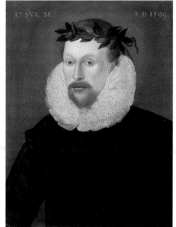

Robert Devereux, 2nd Earl of Essex
After Marcus Gheeraerts the Younger
Oil on canvas, c.1596
635 x 508mm, NPG 180

Michael Drayton
Unknown artist
Oil on panel, 1599
597 x 457mm, NPG 776

the descendants of Sir Henry Lee (1533–1611), held at Ditchley
in Oxfordshire. However, it has since been linked to Sir Robert
Dudley (1574–1649) – the illegitimate son of the more famous
Robert Dudley, 1st Earl of Leicester (1532/3–88) – on the basis that
Henry Lee was godfather to Sir Robert Dudley and it bears good
similarity in facial type to other portraits of Dudley. The balance
of evidence is extremely suggestive and indicates that the sitter is
likely to be Dudley, but it is not wholly conclusive and consequently
the portrait currently has the title 'probably Sir Robert Dudley'.

Sometimes information on the paintings themselves provides
critical clues. For example, in the sixteenth and early seventeenth
centuries it was common to inscribe the date and the age of the
sitter directly onto the painting in the Latin formula 'Anno Domini'
(in the year of our Lord), followed by the date and *aetatis suam*
(at the age of), followed by the sitter's age. We see this in the
example of a portrait of the poet Michael Drayton (1563–1631,
above, right), which has been recently re-identified and includes

an inscription of the same age and date. (The inscription copies another, original, one beneath the paint surface, but visible in x-radiography.) This was done to show that the portrait captured an actual moment in time, and so that the sitter might, in years to come, see how time had aged them. Recent research using x-radiography has shown that sitters sometimes asked painters to make alterations to their inscribed ages by one year at the very final stages of the picture, probably following a recent birthday.[2] This evidence shows that these dates mattered to those commissioning portraits and that a portrait performed a useful means of commemorating actual physical appearance at a moment in time. The portrait of Drayton was recently re-identified on the basis of this inscription, which correlates with Drayton's own known birth date, but the identification is also supported by very close similarity to two surviving authentic portraits of the poet.[3] Future opportunities to undertake further research on the large number of surviving historical portraits of unknown men and women will certainly allow more faces from the past to be identified. As research facilities improve and access to yet more online digital images and documentary sources increase, some portraits will be reclaimed to play their part as illustrations to traditional biographical narratives of history. And yet, as this book shows, there will undoubtedly be many others whose identities have been lost in the chaos of events long passed, and whose appearance will be as intriguing to us for what they cannot tell us as for what they can.

Notes
1. The paint surface has been 'transferred' from a wooden panel onto a canvas support. This was a common technique aimed at preservation in the nineteenth century, but often causes further paint loss and is not used today.
2. Another portrait of an 'Unknown man known as the Grafton portrait' and once identified as William Shakespeare has an original inscribed age changed from '23' to '24'. See: Tarnya Cooper, *Searching for Shakespeare* (London: National Portrait Gallery Publications, 2006), catalogue no. 4, p.62.
3. See: Dulwich Picture Gallery and Westminster Abbey.

THE PORTRAITS

These portraits, dating between c.1520 and c.1640 were all originally purchased by the National Portrait Gallery as identified people. Subsequent research indicated their identities were doubtful. Presented here are details of the media, dimensions and provenance of these pictures and what is currently known about them.

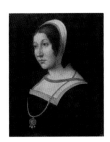

Unknown noblewoman, formerly known as Margaret Tudor (1489–1541)
Unknown French or Flemish artist
Oil on panel (441 x 356mm), c.1520–40

Provenance Owned by the Revd. W.H. Wayne from at least 1886; sold by Wayne to A. Smith of Albert Gate Art Galleries from whom it was purchased by the National Portrait Gallery.
Purchased 1898 (NPG 1173).

The National Portrait Gallery acquired this portrait as Margaret Tudor, sister of Henry VIII and wife of James IV of Scotland. However, both the style and the lack of any securely identified portraits of Margaret Tudor make this identification unlikely. The painterly technique suggests a French or possibly Flemish origin. The woman's costume is also in the style of French court dress of the early sixteenth century. Her gold jewellery and the stylised pomegranate and leaf pattern, commonly reproduced on expensive silks of the period, hint at her noble status. Recent microscopic examination of her medallion has revealed a horseman hunting with a falcon. Falconry and courtly love were frequently linked in medieval literature, so it is possible that this woman is wearing a love token.

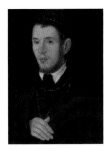

Unknown gentleman, formerly known as Thomas Howard, 4th Duke of Norfolk (1538–72)
Unknown artist
Oil on panel (543 x 406mm), c.1560

Provenance Probably the picture engraved by C. Turner in 1810, which was then in the collection of Mr R. Grave and formerly in the collection of Lady Hyde; purchased by the National Portrait Gallery from Arthur Tooth and Sons, Paris, in 1914.
Purchased 1914 (NPG 1732).

This painting was originally purchased by the National Portrait Gallery as a portrait of Thomas Howard, a nobleman who was executed as a traitor in 1572. However, the likeness does not closely resemble any known portraits of Norfolk. A painted inscription identifying the sitter as Norfolk on the back of the panel probably dates from the eighteenth or nineteenth century.
Microscopic examination of this portrait has revealed quite extensive retouching. The condition of the portrait and the lack of any further information make it impossible to identify the sitter, but he is likely to be a nobleman or a wealthy member of the gentry.

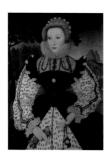 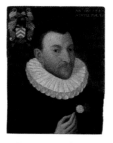 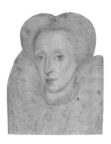

Unknown woman, formerly known as Mary, Queen of Scots (1542–87)
Unknown artist
Oil on panel, transferred to canvas (962 x 702mm), c.1570

Provenance First recorded in the early nineteenth century in the collection of a portrait painter called Stewart, from whom it passed to a dealer named Gwennapp. Purchased from Gwennapp some time before 1845 by Patrick Fraser Tytler, a Scottish historian who identified the portrait as Mary, Queen of Scots (it was formerly known as Mary of Lorraine, Queen of James V of Scotland). Sold to the Gallery by Tytler's son. Purchased 1860 (NPG 96).

When purchased by the National Portrait Gallery, it was thought that this portrait depicted Mary, Queen of Scots. However, technical analysis in the 1960s found that many of the symbols in the painting, including a coat of arms on which the identification of Mary, Queen of Scots was based (now removed), were later additions. The sitter, who does not resemble authentic portraits of Mary, remains a mystery, but the costume indicates that this is a portrait of an English noblewoman. The timepieces may signal the sitter's awareness of human mortality and hope for Christian salvation, or another more complex interpretive programme now lost to us.

Unknown man of the Van Nierop family, formerly known as John Gerard (1545–1612)
Attributed to Isaac Claesz van Swanenburg (1537–1614)
Oil on panel (460 x 364mm), 1587

Provenance Sold anonymously as Gerard at Christie's on 13 July 1901; bought by Parsons; bought by Sir Henry Howorth and purchased by the National Portrait Gallery in the same year. Purchased 1901 (NPG 1306).

The picture has recently been identified as a Netherlandish man from the Van Nierop family, although his exact identity remains a mystery. The identification was made on the basis of the coat of arms. The two carnations (or pinks) held by the sitter were a popular symbol of love during the sixteenth century. It is possible that this painting may have been created as a commemorative marriage portrait.

Initially, this picture was purchased by the National Portrait Gallery as a portrait of the English botanist John Gerard. This identification was based on a superficial resemblance to the engraving of Gerard by Williams Rogers (1598). However, neither the dates in the inscription nor the coat of arms match those of the renowned author of the *Great Herball*, published in 1597.

A pattern for a portrait of an unknown noblewoman, possibly Queen Elizabeth I (1533–1603)
Unknown artist
Pencil and watercolour (184 x 152mm), c.1595

Provenance One of a group of drawings that came into the possession of the Revd. Thomas Bancroft in 1795–7 from the collector John Chamberlaine (keeper of drawings and medals to King George III), who had apparently discovered them in a cabinet discarded from Kensington Palace; sold at Sotheby's on 1 April 1936. Purchased 1936 (NPG 2825).

This rare Elizabethan drawing has long been thought to represent Queen Elizabeth I. The face bears some resemblance to Elizabeth, however detailed research has not revealed any surviving portraits that directly correspond to this pattern. Therefore, the drawing is either a pattern for a lost portrait of the queen, or it may depict a lady of the court who modelled herself after the queen. The sitter is clearly of high social standing and she wears a large ruff, pearl earrings and a pearl jewel in her hair.

The study was produced as a pattern drawing for use in an artist's workshop. Such drawings were used as final preparatory studies in the production of portraits, and also allowed various copies or versions to be made. It can therefore be assumed that the sitter was of enough importance to warrant the circulation of her likeness.

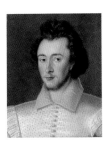

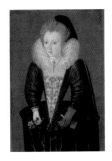

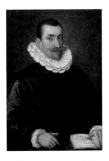

Probably Sir Robert Dudley (1574–1649), formerly known as Sir Thomas Overbury (1581–1613)
Unknown artist
Oil on panel (460 x 372mm),
c.1590

Provenance First recorded in the possession on the Dillon-Lees, Earls of Lichfield, at Ditchley in 1868 as Overbury; sold in the Dillon sale at Sotheby's on 4 May 1933. Purchased 1933 (NPG 2613).

This portrait was previously thought to depict the poet Sir Thomas Overbury, who appears to have been murdered in 1613. However, both the facial likeness and the past history of the painting reveal that it is more likely to represent Sir Robert Dudley, the illegitimate son of the Earl of Leicester, favourite of Queen Elizabeth I.
 In the nineteenth century the portrait was part of a large collection of paintings at Ditchley in Oxfordshire. The house had been part of the estate of Sir Henry Lee (1533–1611), Elizabeth's Champion and godfather to Robert Dudley. It is possible that either Lee commissioned the portrait or that Dudley presented it to Lee and that it remained at Ditchley thereafter. In 1591 Dudley took part in his first ceremonial tilting tournament and also married Margaret Cavendish (d.1595). These events may well have been the reason for the commission of this portrait. The panel painting has been cut down on three sides and was originally larger (perhaps showing both head and torso or even a full-length portrait).

Unknown gentlewoman, possibly Lady Arabella Stuart (1575–1615)
Unknown artist
Oil on paper, attached to panel (187 x 133mm),
c.1595–1600

Provenance Unknown. Purchased 1914 (NPG 1723).

This intriguing image has traditionally been identified as Lady Arabella Stuart due to its similarity to authenticated portraits of the Scottish noblewoman. Arabella was a direct descendant of Henry VII and, as such, represented a rival to Elizabeth I's monarchy. The costume, hairstyle and facial likeness to other portraits indicate that this identification may be plausible.
 It is not clear what purpose this small-scale painting on paper was originally meant to serve. The honeysuckle in the sitter's right hand could be interpreted as a traditional symbol of love. It is possible that the painting was intended as a love token. However, it could also have been one among a series of other small-scale family portraits displayed as a group to demonstrate dynastic links.

Unknown man, possibly John Bull (1563?–1628)
Unknown artist
Oil on panel (360 x 258mm),
c.1600–20

Provenance In the collection of W.H. Cummings, 1904; acquired by A.F. Hill in 1923 and then by descent to Miss Winifred Hill; sold from the Hill Musical Collection at Christie's on 19 November 1965 where it was bought by Barker; subsequently bought by Professor R. Thurston Dart (John Bull's biographer) who bequeathed it to the National Portrait Gallery in 1971. Bequeathed by Professor R. Thurston Dart, 1971 (NPG 4873).

Stylistically, this portrait appears to be continental rather than English, and the sitter's costume reflects late sixteenth- and early seventeenth-century Dutch or Flemish fashions. It is possible that it depicts the English composer John Bull, who served as a royal musician to both Elizabeth I and James I. Bull may have travelled on the continent in around 1602 and he lived in the Netherlands from 1613 until his death. The facial features are remarkably similar to other known portraits of Bull, but without further evidence it is difficult to provide certain identification.
 The lyrics on the musical score translate as 'I saw her, I love her, and I will love her', indicating that this portrait may have been a personal love token. Curiously, a large baton (or perhaps a bow) in the man's hand has been partly painted out. It can still just be seen and probably represents a change in the composition by the artist.

93

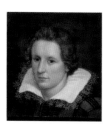 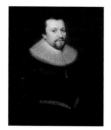 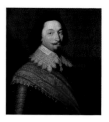

Unknown man, possibly William Drummond of Hawthornden (1585–1649) Unknown artist Oil on panel (222 x 200mm), c.1610

Provenance Unknown. Purchased 1899 (NPG 1195).

The identification of this portrait as the Scottish poet William Drummond is not certain. It is based upon the facial likeness of the sitter to a portrait of Drummond in the Scottish National Portrait Gallery. The similarity in their costumes suggests that both portraits depict a man of high social status. The swept-back hair, embroidered doublet and intricate rising lace collar are typical of early seventeenth-century court fashions.

Recent restoration indicates that this work may have been cut down from a larger painting, explaining the small size of this panel. The slightly awkward positioning of the eyes indicates that the artist was challenged by the demands of this pose.

Unknown man, formerly known as Sir Ralph Winwood (1562/3–1617) Unknown artist Oil on canvas (756 x 629mm), c.1620

Provenance Purchased from Thomas Moore of Cambridge Street, Hyde Park; previous history unknown. Purchased 1858 (NPG 40).

This portrait was purchased in 1858, just two years after the National Portrait Gallery was founded. Recent cleaning has allowed this painting to be dated to the early seventeenth century. It was originally considered to depict the prominent diplomat and politician Sir Ralph Winwood of Northamptonshire. However, the sitter only slightly resembles the known portraits of Winwood.

The man's clothes certainly suggest that he was a member of the gentry or a successful professional man. However, due to the lack of any further significant information concerning this portrait's past history, the identity of the sitter is likely to remain uncertain.

Unknown man, formerly known as George Villiers, 1st Duke of Buckingham (1592–1628) Attributed to Cornelius de Neve (before 1594–1678) Oil on canvas (657 x 613mm), 1627

Provenance Unknown. Purchased 1903 (NPG 1346).

This portrait was once thought to represent the nobleman George Villiers, 1st Duke of Buckingham, a favourite of King James I. However, this identification has now been revised as the sitter's features bear little resemblance to other known portraits of Buckingham.

The identity of the sitter is not known but he is unlikely to be British. The distinctive orange sash is similar to those worn by officers of the Dutch army in the Netherlands who served under the Princes of Orange. It is therefore likely that this dashing man is an officer in the Dutch militia.

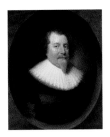 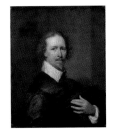 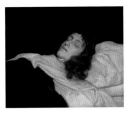

Unknown man, formerly known as Richard Weston, 1st Earl of Portland (1577–1635)
Cornelius Johnson (1593–1661)
Oil on panel (765 x 623mm), 1627

Provenance Offered to the National Portrait Gallery as a portrait of Sir Edwin Sandys (1561–1629) by a Mr Vasper, who stated that it had belonged to the Sandys family of Miserden, after which it had passed to the Merryweather family; identified by Sir Lionel Cust as Portland and purchased by the National Portrait Gallery in 1903. Purchased 1903 (NPG 1344).

The sitter in this portrait was once identified as Richard Weston, 1st Earl of Portland. However, comparison with other portraits of Portland casts doubt on this identification. It is possible that the sitter is a member of the Sandys family, perhaps Sir Henry Sandys, the younger brother of the founder of the Miserden branch of the Sandys from Gloucestershire. Although little is known about Henry, we do know that he married in 1602, making it conceivable that he was middle-aged when this portrait was painted.
 Cornelius Johnson was one of the most accomplished portrait painters working in England at this date. The son of a Dutch exile, Johnson painted portraits of the gentry, professionals and members of the court from the 1620s.

Unknown man, formerly thought to be a self-portrait by Cornelius Johnson (1593–1661)
Oil on canvas (768 x 622mm), 1636

Provenance Sold from the Ravensworth Castle collection on 15 June 1920; acquired by the National Portrait Gallery the following October; previous history unknown. Purchased 1920 (NPG 1887).

This painting was purchased as a self-portrait of the talented English-born artist Cornelius Johnson. However, the sitter's features bear little similarity to authenticated portraits of Johnson.
 The sitter is presented simply and without decoration. His sober costume, broad shoulders and pointed beard conform to contemporary ideals of masculinity and fashion. The high-quality satin doublet suggests that the sitter was reasonably wealthy. His gesture of pointing towards his chest may be intended to emphasise his virtue, strength of character and self-reliance. Similar gestures are occasionally found in other portraits of writers, artists and successful professional men.

Unknown man, formerly known as James Scott, Duke of Monmouth and Buccleuch (1649–85)
Unknown artist
Oil on canvas (565 x 667mm), c.1640

Provenance Possibly belonged to members of the Wray family in the late eighteenth and early nineteenth century; discovered in a farmhouse near Knole, Kent in the late nineteenth century; acquired by Haden in London before 1892. Purchased 1910 (NPG 1566).

This unusual portrait of a man on his deathbed was thought to depict James Scott, Duke of Monmouth, and the eldest illegitimate son of Charles II. He was beheaded for leading the Monmouth Rebellion in 1685. However, the length of the hair and style of this portrait suggest a date in the 1640s. Therefore this portrait cannot represent Monmouth.
 Deathbed portraiture had some popularity in the 1640s; it helped to secure the reputation of the deceased and provide a visual memory for the bereaved. The identity of the sitter is not known, but one possibility is the nobleman Edward Sackville, son of the 4th Earl of Dorset (1590–1652), who was buried a month after his death in 1646. His marriage to Bridget Wray may explain the Wray family's subsequent ownership of the portrait during the nineteenth century. However, lack of further evidence means that this identification remains inconclusive.

ACKNOWLEDGEMENTS

The National Portrait Gallery would like to thank all the authors for agreeing to be involved in this project and kindly allowing their work to be published in this volume. We are also very grateful to the following students at the University of Bristol, and their tutor Dr Tatiana String, for their help with the research on these portraits: Anna Bonewitz, Helen Bowden, Kana Enokido, Dora Fisher, Maria Hadjiathanasiou, Holly Lopez, Cressida Nash, Julieta Ogaz, Melanie Polledri, David Roberts, Cicely Robinson, Etsuko Shimoya and Jenni Styles. We are indebted to Professor Rudi E.O. Ekkart, Director of the Netherlands Institute for Art History, who provided the new identity of the sitter formerly known as John Gerard. Thanks are also due to Catherine Daunt for her outstanding support in the co-ordination of this publication and the accompanying display. We would also like to thank the National Trust and the staff at Montacute House, Somerset, where an earlier version of this display was shown.

Published in Great Britain
by National Portrait Gallery Publications
National Portrait Gallery
St Martin's Place
London WC2H 0HE

Published to accompany *Imagined Lives: Portraits of Unknown People*, a display at the National Portrait Gallery, London, December 2011 – June 2012. Some of the texts in this book first appeared in *Imagined Lives: Mystery Portraits*, published in 2010 to accompany an earlier version of the display at Montacute House, Somerset, where the National Portrait Gallery displays a major collection of sixteenth- and early seventeenth-century portraits.

For a complete catalogue of current publications please write
to the address above, or visit our website at www.npg.org.uk

ISBN 978 1 85514 455 2

A catalogue record for this book is available
from the British Library.

Managing Editor: Christopher Tinker
Design: Smith & Gilmour
Production Manager: Ruth Müller-Wirth

Printed and bound in Italy.

MIX
Paper from
responsible sources
FSC® C015829